RESURRECTION
ORACLE

T0405395

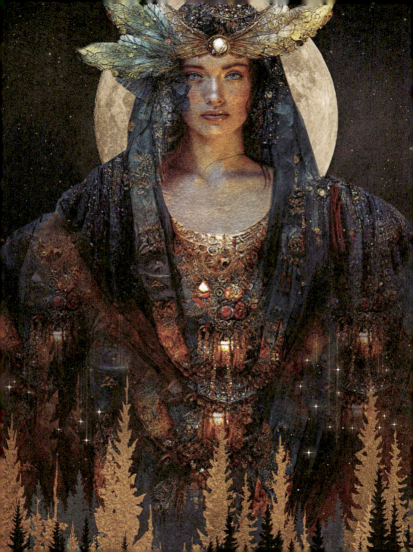

RESURRECTION ORACLE

WELCOME TO YOUR LIFE

Jena Dellagrottaglia

ROCKPOOL

A Rockpool book
PO Box 252
Summer Hill
NSW 2130
Australia

rockpoolpublishing.com
Follow us! **f** 🅾 rockpoolpublishing
Tag your images with #rockpoolpublishing

ISBN: 9781922785800

Published in 2024 by Rockpool Publishing
Copyright text and illustrations © Jena Dellagrottaglia 2024
Copyright design © Rockpool Publishing 2024

All rights reserved. No part of this publication may be reproduced,
stored in a retrieval system, or transmitted in any form or by
any means, electronic, mechanical, photocopying, recording or
otherwise, without the prior written permission of the publisher.

Design and typsetting by Sara Lindberg, Rockpool Publishing
Edited by Heather Millar

Printed and bound in China
10 9 8 7 6 5 4 3 2 1

ACKNOWLEDGMENTS

Thank you to my beautiful husband who always encourages me to dream bigger.

To Lisa who is patient with me and believes in what I do, thank you.

To those who are moved by my art and vision. I am forever grateful.

To this thing we all do together called life, thank you for being a selfless teacher.

I am filled always with gratitude and kindness.

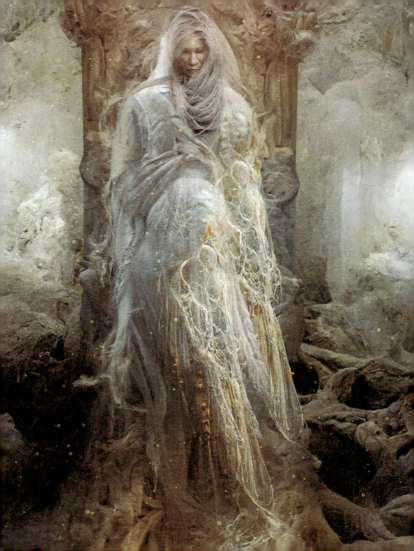

CONTENTS

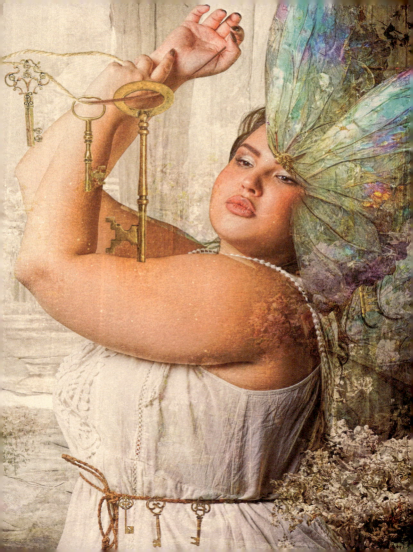

INTRODUCTION

*Welcome to your life. Here is a place that
is complex, full of events, emotions, and
moments that shape us continually.*

It is beautiful, it is messy, and it is sweet and sour.

*Life constantly changes us, forcing us to naturally
resurrect and have a metamorphic experience.*

*This oracle deck is meant as a guide,
not a blueprint. Welcome to the
next part of your journey.*

Resurrection Oracle is a 36-card deck created for both seasoned intuitives and first timers alike. The deck focuses on some of the important milestones in life, the emotions we are taught to feel, and how we are supposed to deal with certain situations. The cards can also be read daily and applied to everyday life, as well as our victories and/or struggles. Each moment is truly unique from any other, no matter how similar the circumstances might be.

Life and death can be hard to navigate, and we look for guidance from within, without, and into the universe. I often say to myself or my children, "Life isn't always easy. Sometimes we get what we feel

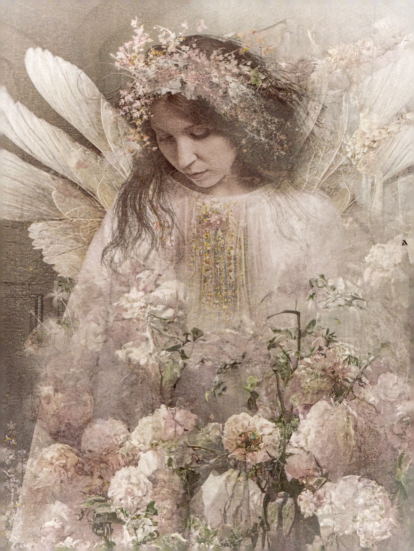

is more than our share. It is not the moments that define us, it is the choices we make and how we move through these times that can really become a credit to who we are or a shame."

Sometimes we need a reminder that it is okay to cry, to yell, to play, to shine, to heal. So it's important to validate our feelings, find acceptance in ourselves, and seek no one else's approval. Throughout our lives, there will be times when we will feel as if we have died and, at other times, as if reborn, depending on the cycles of life and our place in them.

Each resurrection redefines us.

I hope this deck helps you move through life with grace and authenticity, and to be more self-assured in the moments of your very own story.

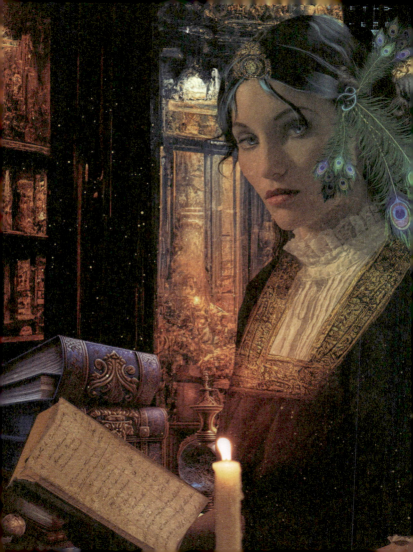

HOW TO USE THE CARDS

DAILY MESSAGE CARD PULL

1 2 3 4

✦ **Card 1:** Focus on your shuffle, how the cards feel in your hands. Don't rush the process; really connect with the cards.

✦ **Card 2:** Ask the oracle/universe or your higher power a question.

✦ **Card 3:** Select your card after making a single stack and fanning them out. Decide where you feel compelled to pick from.

✦ **Card 4:** If you feel the message doesn't make sense or apply to your question, don't worry, it will at some point in your day.

You might not always understand it immediately and that is okay. Trust the cards and your intuition. Go about your day and remember the card and its message. Somewhere along the way, it will make perfect sense to you.

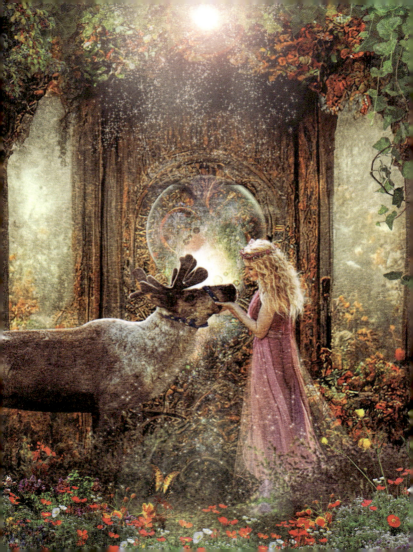

BEGINNING, MIDDLE, AND END CARD PULL

1 2 3

- ✦ **Card 1:** Connect to yourself, really feel in tune with you. Trust
- ✦ your intuition.
- ✦ **Card 2:** Shuffle your oracle cards and ask yourself for knowledge in the reading. Stay focused on your question or search for insight.
- ✦ **Card 3:** Select your three cards however you feel most comfortable choosing them.

These cards may be lessons or reminders, ways for spirit to let you know you are not alone, and that you are cosmically connected to all. Keep these cards in mind as you go about your week, paying attention to the sequence. How does the first card relate to the beginning of your week? How does the second card correlate to your mid-week? And how does the third card correspond to the end of your week?

WEEK IN DEPTH PULL

Connect to yourself, perhaps really meditate while you handle the cards. Have knowledge that your intuition is on point.

Shuffle your oracle cards and ask yourself for clarity, knowledge, and guidance for this week. Remember, this is all about the human experience, but part of being human is that deep, soulful knowledge.

Select your seven cards for each day of the week however you feel comfortable doing it. Some may choose to make three stacks and pull from there; others may fan the cards out and pick those they are most drawn to.

Like in the three-card pull, these cards may be lessons or reminders, a tone for the day. Keep these cards in mind as you go about your day and week.

THE
CARDS

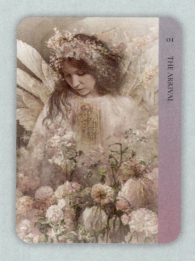

THE ARRIVAL

CELEBRATION OF LIFE

This card is a symbol of birth. It does not necessarily mean the actual act of giving birth. The arrival is a joyous occasion, a time for celebration and gathering. You, your birth, your life is a gift to the world and especially those who love you. Never forget that – you are a gift to the world. You and your unique perspective, personality, and life. Today, celebrate yourself and your arrival the best way that

honors you. Get yourself a little something special because you are worth it. Do something that brings joy to your world.

The arrival card can also mean the birthing of something wonderful: a project, a child, a creation. See this into fruition; this is the arrival of something amazingly wonderful.

REVERSE

Have you forgotten that upon your arrival, people celebrated you and your delivery into this world? If so, take time to celebrate your life: give yourself affirmations and do the little things to celebrate all you bring into the world that is unique to you and your being.

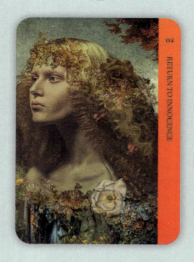

RETURN TO INNOCENCE

FIND WONDER

Remember being a child? Filled with wonder and joy, in awe of the simplicity of everyday things, with a sort of blind faith and trust in everything you knew? This is your reminder: today, find that wonder, that way of looking at the world through a child's wide eyes and return to innocence.

REVERSE

Perhaps you have become jaded and cynical, with a negative outlook. Stop and pause – think about the wonder of being alive, about how the human body works. It is awe-inspiring. Move forward from there – think about how the world is, how you and everything surrounding you was created. Meditate, breathe, and return to innocence.

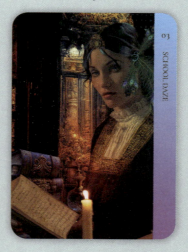

03
SCHOOL DAZE

SCHOOL DAZE

SELF-ENRICHMENT

You are on the quest for self-enrichment, higher learning, how to unlock something – perhaps not academically, but spiritually. You are never too old to learn something new and widen the playing field in your life. So if you are questioning going back to school, learning a new craft, or how to meditate, you are on the right track. Remember, it takes time to master something new. Be patient with yourself. Unlock your mind and get ready to absorb all things new.

REVERSE

You can't teach old dogs new tricks! Well, certainly not with that attitude, you can't. But with enough patience, you can indeed. Take the time to recall your first day of school as a child and how excited but nervous you were. Time to get back into that mode. Put on your proverbial thinking cap and give yourself extra credit for venturing into the extracurricular activity of self-enrichment.

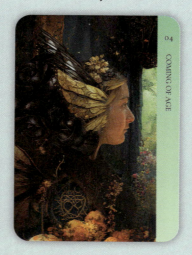

COMING OF AGE

EMBRACE AWKWARDNESS

What can we say about coming of age? It's that awkward, emotional time in everyone's life. Your emotions are on a rollercoaster, and you hardly ever give yourself enough credit. This is a time to embrace your uniqueness. How boring the world would be if we all lived in a cookie-cutter, mass-produced world. Today is a good day to face those awkward moments, the self-doubt, and all the negative self-thoughts you are having and just be gentle on yourself. Tell those

emotions "Not today" and affirm how wonderful you are just for existing and bringing your uniqueness into the world, knowing you and your unique brand are appreciated.

REVERSE

The cock of the walk, the bee's knees, all that and a bag of chips. That's you – and, boy, do you know it. Keep on loving yourself and believing in yourself. We love this energy! And it looks great on you.

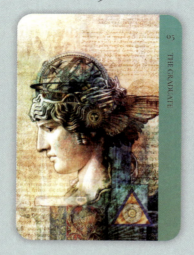

THE GRADUATE

LESSON LEARNED

You have learned all you could in your current status and position in life; it is time to graduate and move forward into the unknown, which might seem scary. There is no cause for alarm, it's just time to celebrate your past achievements and move on to things that challenge and take you from your comfort zone. Perhaps there is a promotion available in your current workplace, or maybe you feel

stagnant and unmotivated there. This is always a good indicator that you have graduated — now, be bold and brave as you face the future.

Ask for that promotion; browse the wanted ads; update your resume. Don't be afraid to spread your wings and know your worth. It might surprise you how rewarding it is. You could even try volunteering one day a week to see how it feels to be in a new situation.

———————◆———————

REVERSE

Are you feeling unable to catch on and gather the basics of your day to day? Maybe it is hard to focus where you are now. Ask yourself the following questions:

Am I giving this my all? Am I just here for a paycheck? Will I ever be promoted? Will I be fired for not applying myself? Can I find joy in what I do?

If any of your answers indicate it might be time to move on, give yourself a final test before graduation. Try applying yourself fully, immersing yourself in your day and the tasks to hand. If you have no joy or love for what you do, perhaps it is time to look inward and consider what *would* give you joy – a joy that could help sustain your lifestyle into the future.

Sometimes it is easy to get stuck, afraid to move forward, but anything worth having and experiencing is worth the risk.

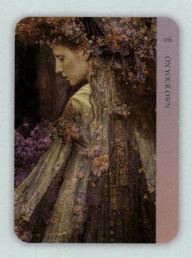

ON YOUR OWN

WHO ARE YOU?

Moving out by yourself, breaking off from situations, the children moving out, the loss of a loved one – how to find comfort in being alone is never easy.

Being alone can sometimes seem like one of the scariest places to be. Left to your own devices, immersed in your own thoughts and feelings, responsible for your own decisions – there is no one to blame

but yourself. And let's face it, sometimes we can be our own worst critics and enemies.

Get out of that headspace and do something productive: decorate; make the space you live in uniquely yours; validate yourself by journalling your emotions, leaving all that negative shit on the paper where it belongs, then note your wonderful qualities. Embrace this time in getting to know who you truly are, without someone else's expectations, criticisms, or sometimes even judgment. You might actually find that you have come to love, respect and value who you really are without other people's limitations on you.

REVERSE

Are you feeling suffocated by those around you? Not literally, of course, but sometimes you can't even hear your own thoughts. Now is a good time for a you-cation. Take at least an hour to isolate yourself from others – go to a yoga class, take a drive, have a bath, go on a night out, meditate. Be yourself, and don't identify in these 'you' moments as the spouse, the child, the parent, the partner. Appreciate the quiet in whatever you choose to do on your own.

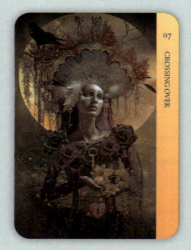

CROSSING OVER

SHEDDING THE OLD

Crossing over is not necessarily a bad thing. When you cross over, it is time to say goodbye to the you that you once knew. This card is about opportunity and change, leaving behind who you were, as a snake sheds its skin; it is a card of reinvention into a new existence. You could call it a rebirth or phoenix card, so to speak. There is a different window to look out, a fresh view and perspective to gain, a beautiful door to unlock. Uncage all your fears and let them melt into the ether.

Go into the new with a positive outlook filled with excitement, verve, and curiosity. This will help you live the best life you can, honoring your new rituals, regimens, and way of life.

REVERSE

Did you see all the signs to cross over into your new life but failed to follow them? This means you were not truly ready to shed the life you knew, or say goodbye to the person you had become. And that's okay; just don't get stuck in a world where you only look out one window or have locked all your doors. Chances are you will become a ghost of the person you are meant to be.

A LIFE WELL LIVED

WHATEVER YOU WANT

You are absolutely doing life right, and you know that not all things worth having can be bought; rather, they are cultivated, honed, treated with respect, and appreciated. You are authentic and genuine, living a life worth living. You share your wealth, whatever it might be, and pass on your knowledge and encouragement freely. You love deeply.

It is here – at this moment – you can do whatever you set your mind to. So get up and do whatever you dream.

REVERSE

Why aren't you making more out of your time here? Life is precious, and it is short, but it is the longest thing we'll ever do. This means take from your mistakes and failures and build, grow, find your courage to give it another go. That is the beauty of this life – you can keep going until you get it right.

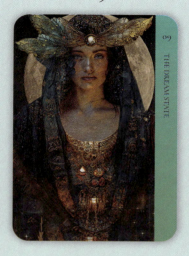

THE DREAM STATE

UNWIND YOUR MIND

Here is a place where all things are possible … in deep slumber you are shown the wildest of fantasies, and reconnected with your deceased loved ones. Dream up something fabulous and new that you might bring to fruition.

Take time before bed to unwind, unplug, and rest your mind to ensure you have the best chance possible to make your dreams sweet.

A dream journal is a wonderful idea because you never know the interpretation or message a dream might hold, especially first thing in the morning.

I once heard that if you touch your head when you wake, you will forget your dreams. True or not, I try desperately to not do this upon waking, just in case.

REVERSE

Yours is the stuff of nightmares, or truly crazy, fractured dreams where it starts out lovely and takes a turn for the worse …

It is so important to soothe and quiet your mind before sleep. Using technology right before bed definitely over-stimulates the mind – consider if this could be the catalyst for your disturbed dream state.

Or maybe something is weighing heavily on your mind or soul. This happens to the best of us, though these emotions can really stir up a whopper of a scary and/or chaotic dream state.

Try some lavender essential oil, drink some chamomile tea or something natural and healthy to help ease you into a peaceful slumber.

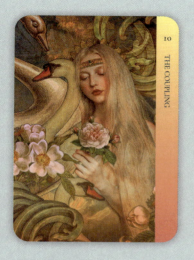

THE COUPLING
MUTUAL RESPECT

It takes two to tango – have you found that special someone who drives your heart to beat faster, lights a fire in your soul, and stimulates you intellectually?

Any relationship worth having is truly worth working on; it is at times a delicate dance. So if you are feeling a deep connection and are hopelessly devoted to this person, give it a true go. Be sure you

are both willing to give and take, and try to go in without comparison, expectations, or cynicism.

Open yourself fully. Remember, each proverbial window has a different point of view. So take in their perspective, and try to understand where they are coming from. Life is too short for emotional games or holding out.

REVERSE

Are you all that matters? Do you often complain and find that most of your complaints start with "I"? Perhaps this is not the right situation for you, or perhaps you have been solitary for too long.

Maybe you forgot what it is like to give freely of yourself and listen to another person's perspective on things. Now is a good time to assess this, so let's unpack a few things by asking yourself some questions.

Have I closed myself off and put up a wall? Am I used to and unwilling to open myself up to this and new experiences? Am I ready to be a team player and go in for the win? Am I ready for this on all levels: physically, mentally, and spiritually?

You do matter, and it is good to open yourself up to different experiences and relationships.

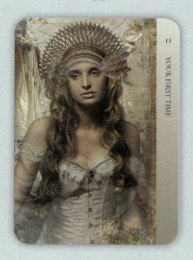

YOUR FIRST TIME

NO INHIBITIONS

You experience many first times in your life – from intimacy, to food, to family situations. Trying something new, experiencing someone new, visiting some place new – all this should be exciting, filling you with anticipation and a dash of nerves.

You are not always going to like each different experience, nor will any experience be the same. Close your eyes, and imagine this

first time as a gift – because no matter what, there will never be this first moment again.

Surrender to the person, the relationship, the cuisine, the job … Go into it with wonder, even though you don't know exactly what is in store for you. No preconceived ideas, and little to no inhibitions.

The worst thing that could happen is you don't fully enjoy and appreciate the moment, or perhaps you feel awkward in the situation. At least you can say, "I tried honestly and fully."

REVERSE

Are you stuck in a pattern, afraid to try new things, or jaded perhaps to new situations or people? Maybe you think there is nothing different left for you to try.

You are wrong – there is absolutely a first time for something you have yet to do. Sometimes you can hold on to trauma or unpleasant memories that keep you from experiencing life and all it offers.

I am inviting you to start small: perhaps a first time for a new food you have always been curious about? A hair color? A hobby you wish you could try?

Let's start here, slowly, and get acclimated to new situations.

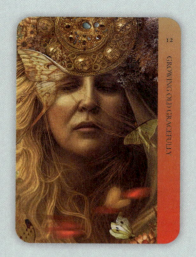

GROWING OLD GRACEFULLY

AUTHENTICALLY YOU

Life has a funny way of showing up on your face, and this is okay. As they say, youth is wasted on the young. But is it?

When you grow old gracefully you embrace the life well lived, and are proud to show your wisdom and experience. I am not talking about avoiding a new retinol cream or eye serum here; self-care is very

important. I am talking about living in your wisdom, being unafraid to speak your truth. Not getting lost in the quest for eternal youth because you are busy living a full and rich life.

Society has made it "the standard" for people to not age, or let gravity show. Shame on society for this because gravity happens to every one of us. Don't be afraid to show your age and do not let other people dictate what is beautiful and/or acceptable. There is beauty everywhere; you are absolutely no exception here.

REVERSE

Act your age?! Well, not necessarily. To make the most of life, it's important not to taking yourself too seriously.

If you're stuck thinking "When I was younger I used to be skinny, had flawless skin, was bright eyed . . .", are you so lost in your search for eternal youth you are forgetting to live today? You have evolved beautifully, and I am inviting you to look at yourself with kind eyes today.

Have you ever heard someone body-shamed or trolled for not being up to society's beauty standards? Did you get livid that someone could be so cruel to a stranger? Then why would you allow yourself to be so cruel to yourself? Look in the mirror, and find your beauty, your grace – say something wonderful to yourself.

Carry this grace with you through your day today.

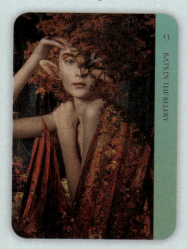

BATS IN THE BELFRY

FACING CHAOS

Some moments can just make you absolutely "batty". Whether from anxiety, depression, or just a plain old moment in a certain situation.

It is okay to not feel in control, or to feel whatever you do actually feel. But don't hold on to this moment for too long. Don't allow yourself to get lost in the moment's chaos or even a string of similar moments. Don't let the insanity define you. Seek a way that is healthy to work through it.

REVERSE

Rigid, calculated, unfeeling, not the emotional type? Maybe you just honestly let everything roll off your back or maybe everything is compartmentalized? Well, dear soul, if you hold everything down, you are suppressing your emotions. The more you tamper, the more you become like a pressure cooker, ready to spew out all the mental and emotional ingredients you have been holding down. May you genuinely feel and digest situations.

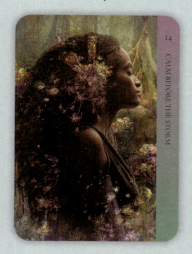

CALM BEFORE
THE STORM

ENJOY THE SILENCE

Sometimes life can be peaceful, quiet, even unremarkable. Take these times to enjoy and appreciate the calm.

Life is full of unexpected storms, but not every storm must leave you riddled in chaos or uproot you from the shelter of "home".

It is how you handle these moments and ride the storm that can define an outcome.

Sometimes it is easier to navigate, other times there will be some damage. You cannot prepare for every storm, but remember there will be calm and sunny days again.

REVERSE

A whirlwind of chaos, a hurricane, a mess. Do you thrive in the drama or chaos that life throws your way? Or do you get stuck just wallowing in the mud left behind? Find a calm and soothing focal point, an exit out, a calming shelter. Find a way to ride the storm.

Remember, if you are a hurricane, you are the *eye* of the hurricane, and you may not see all the surrounding devastation you leave in your own path.

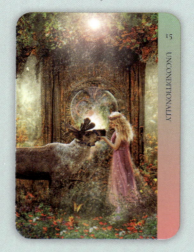

UNCONDITIONALLY

NO RESERVATIONS

Without limits or conditions … most times, the word that comes up is "love". But more than love can be unconditional – you are being asked to let go of putting limitations on yourself.

"In what capacity?" you might ask. In a way where you are unafraid to open yourself up fully to the possibilities set before you. It could be love, creativity, invention, work.

What in your life at this moment is crying out for you to approach it without reservation and be fully unconditionally committed?

Dive right in.

———————————— ◆ ————————————

REVERSE

Boundaries are the word of the day. Let's set some.

You have this knack for not setting limits where some are required. Are you questioning if you have crossed a line? You might well be treading too close to someone or something that has a borderline that is not ready for you – or you are not ready for. Tread lightly.

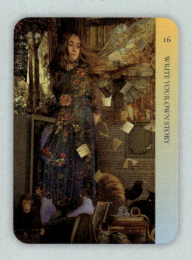

WRITE YOUR OWN STORY

THE SKY'S THE LIMIT

This is your epic tale, with many chapters, side notes, and acknowledgments. You are the main character here. Your adventure has no guidelines – the sky's the limit.

You don't always need to be the champion, the victim, the complacent person. The beauty of this story is you just keep writing

because you are the master of your destiny. This story (mistakes and all) makes up who you have become, who you will be.

Take some risks, have some fun. Make this a great read.

REVERSE

Are you letting someone else be your main character? Or are you trying to be the primary focus in someone else's story? Stick to your own script – you handle you and your outcome. Let's make this read a non-drama. Once you realize this is not your major story, the easier it will be for you to focus and write the most epic story you can for yourself.

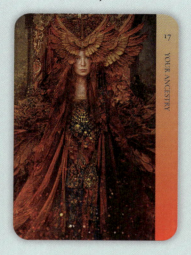

YOUR ANCESTRY

IT'S ALL RELATIVE

Generations that have come before you, the people who formed your traditions, your structures, your foundations – these are your roots, paths, stories, and the very soul of your family tree. It is a good thing to remember them, sit in silence, and reconnect with them.

There is a lost wisdom within them, a sort of deep familial magic. If you will, they are your family's myths and archetypes.

Sometimes you can get so caught up in what is new and exciting you forget all that came before you. Maybe you have a love of music, art, math, or some other natural gift and you do not know where it came from. Chances are, somewhere back in your ancestry someone was gifted in the same way you are.

Give thanks for this, and hold dear the traditions and roots that were created as if by magic by those who came before you.

REVERSE

Are you caught up in the "curse" of your ancestry? What does this mean exactly? This means you are stuck in the old ways, not evolving, following your ancestors' patterns and cycles even when harmful.

While still honoring your roots, you can respectfully let them know how much you appreciate their sacrifices, their journeys, and their stories, and that you will hold dear certain traditions, but the time has come for you to forge your own and make a new path for future generations to look back on and understand.

Sometimes breaking the cycle is the best thing you can do for yourself and your family, creating a healthier environment for those around you and those yet to come.

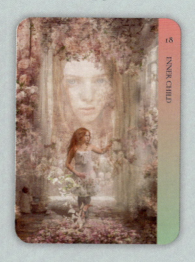

INNER CHILD

HEALING IS DIFFICULT

Your inner child has been tucked away neatly inside, for protection. Sometimes childhood trauma forces a child to grow up too quickly, because you come face to face with adult situations that your young self is not equipped to deal with, and rightly should not have to deal with. This is an unfortunate fact of life and death – a total fight or flight for the child you were and still are somewhere inside.

These events can be hard to revisit, but that child is searching for healing. Write your inner child a note, or give your inner child an affirmation, letting them know this event was not their fault; they were innocent and caught in the crossfire. When you are ready to let go of the trauma, burn the note or letter, or send a balloon into the atmosphere and release the pain in that moment.

REVERSE

You have done the work, or perhaps most of it, to get the healing process going for your inner child. Today you are invited to do something your adult self might not do. Roller skate, play, have fun in a way you would as a child. Enjoy the day and set aside the worry of being an adult.

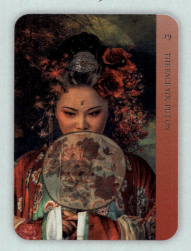

THE FACE YOU PUT ON

SURVEYING SITUATIONS

Act confident, put on a brave face, keep your chin up, and so on and so forth . . . you know the lines.

Who do you want or need to be today?

Some days, it's all about how you face the world and your outlook. The fact that you are handling moments with finesse, savoir faire and tact? Good for you – some moments in life require this.

You are not being asked to be inauthentic, but you are being asked to assess situations and know how to manage or get through a moment.

REVERSE

Have you gotten used to putting on a mask or "managing" situations? Perhaps you have forgotten who you genuinely are or what and how you actually think or feel about every moment.

This could be because you are always "on".

Find your off switch or at least step back from situations and question yourself on your authenticity.

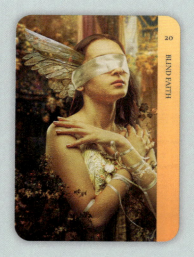

BLIND FAITH

COMPLETE TRUST

Sometimes seeing is believing, but in this case you are being asked to trust. Trust in the process, in yourself, in all you have invested in you.

You might not see it manifesting just yet, but that doesn't mean it's not coming together as you hoped and dreamed.

This is a reminder you cannot see atoms until they come together to manifest something tangible.

REVERSE

You can be too easily trusting, and this can lead to moments or situations where you are left vulnerable, a victim, or plain out just getting hurt.

You are being asked to take off the blinders and seek the answers you desperately need.

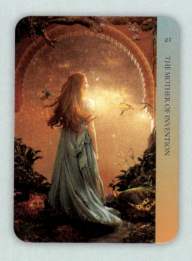

THE MOTHER OF INVENTION

SPARKING INGENUITY

It has been said, "Necessity is the mother of invention." Simply put, if there is a need for something, someone will invent it.

Are you finding a need in your life that is not being met? Invent or even reinvent a way to fulfill this necessity.

You might need to get creative and use your ingenuity to create something either totally new or more efficient. It may take patience, experimentation and a few failed tries.

REVERSE

You might be mistaking want for need. There could already be an easier way to get what you want.

It seems you may be over-thinking and complicating something that has already been figured out. Take a breath, and look around and within.

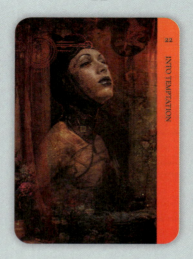

INTO TEMPTATION

LED ASTRAY

In our world today, there are so many ways to be tempted. Whether it's as innocent as skipping a workout day to being led into something that rocks your world. When this card appears, you are questioning temptation. If you are seeking guidance, then chances are you already know the answer.

Now is a good time to be brutally honest with yourself about the ramifications of your actions. Simply put, if you can't live with the

consequences – at all levels – then don't let temptation lead you down its path.

REVERSE

When this card is pulled in reverse, you are super rigid with rules and routine. You've likely always followed things by the book and have been obedient.

Have some fun, eat that carb or dessert. Do something a little tempting. Bend a rule just a smidge.

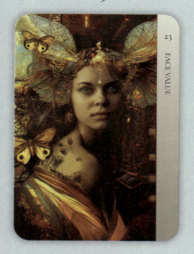

FACE VALUE

TRUE TO YOU

"My word is my bond" – you've heard this saying before. In actuality, face value is about currency – the face value of a coin or bill – but its usage here is about taking someone on face value.

This means, simply, speak the truth. Because you are only fooling yourself and destroying your own value if you do not.

When you meet someone for the first time, you are taking them at face value, trusting their actions, words, and demeanor.

What you can offer in return is the benefit of the doubt. When interacting with someone new, or perhaps not so new, it is imperative that you stay true.

If you are asked to do a task, or perhaps interact with others, and you feel you cannot do the task at hand, let the person who asked you to fulfill this task know. Honesty is the best policy. That's being true to you.

REVERSE

Blatantly truthful, honest to the core. This is a fine quality when used with tact and grace. It is hard sometimes to know the difference – for some people – between the absolute, naked truth and someone just being mean.

You are applauded for your honesty; however, watch your delivery of it.

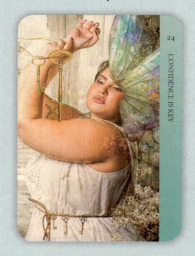

CONFIDENCE IS KEY

EVERYBODY IS BEAUTIFUL

You are beautiful; there is no other like you. Have confidence in yourself. Don't let other people add doubt or uncertainty into your head. But mostly don't let your own negative, self-doubting voice talk you down, or shake you up.

Be kind to yourself, and when you hear that little voice in your head externalize it. This means, if you overheard two people having

the dialogue that you have with yourself internally, would you consider it kind and acceptable, or is it mean, bullying, abusive even?

It's time to shut that negativity down and start building yourself up.

REVERSE

You are so confident – it's a beautiful thing. However, it may teeter on the edge of being arrogant or conceited. Maybe you need to dip your toe into humility to help ground you.

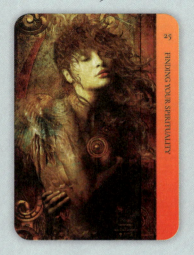

FINDING YOUR SPIRITUALITY

YOUR SOUL FOOD

Some of us take the spiritual path our parents guided us onto when we were small, and others must journey within and throughout to find what resonates in them and stirs their soul.

Remember, each person has their own journey and destination. It is great to find a spiritual community and be with others who share

your beliefs and thoughts. It is equally important to remember others may not find your beliefs in line with their own.

This is okay – you are being asked to find your *own* spirituality inside yourself. With that, hopefully you find patience, peace, understanding, and respect for others.

Take care how you express yourself in terms of your spirituality – becoming overly zealous can be off-putting and intimidating for others who do not share your point of view.

REVERSE

Are you finding it hard to believe in anything greater than what you can see right in front of you? When pulling this card, it usually means you doubt the bigger picture – the spiritual side of things that you cannot see but take on faith.

It is okay to question this; however, try to remember what a miracle just being alive is. How could there not be something more ethereal at work here?

During this time, respect all life. Live a life to be proud of, and remember to be kind to others and have gratitude for all you have.

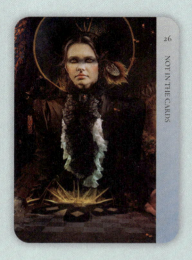

NOT IN THE CARDS

SURRENDER TO PATIENCE

Sometimes you want so badly for something, but it just wasn't meant to be. That is okay. Maybe now is just not the time. That doesn't necessarily mean it will never happen. It means, at this moment in time, "Nope" is your answer here.

Find acceptance and patience with this and maybe try again later. Even if it is never in the cards, don't get discouraged.

REVERSE

All your cards make perfect sense; everything seems to be aligned for you at this moment. Now is the time to act on what you asked for.

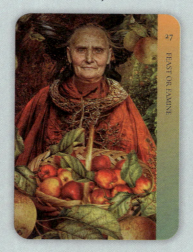

FEAST OR FAMINE

ENOUGH *IS* ENOUGH

We have all heard the expression "Enough is enough." Usually, as a rule of thumb, when we have heard this it *is* more than enough. There is great abundance. However, there are leaner times as well.

This card is letting you know that as long as you have enough, you are just fine.

While having a big bounty is quite a cushy and comfortable place to be, enough is alright too. Just keep in mind that more is coming your way and trust. More money, more love, more life.

REVERSE

You are tired of the famine – the long drought – or what you perceive as such. It is easy to get lost in the haves and have nots when you feel you are deserving of more out of life.

Envy is a terrible vice to have, because as long as you are trying to live up to someone else's life standards, you miss out on your own.

It might look lovely seeing it from the outside, but we never truly know what someone else's famine looks like.

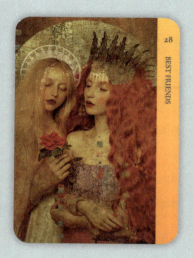

BEST FRIENDS

CHOSEN FAMILY

Chosen family is so important; these are people you choose to be in your life. There is no vow or oath that binds you together. They are here simply because of a bond, a friendship that is so deep and strong. Like a kindred being, some magic takes control and forms this friendship.

Best friends share most of their important life events with you. Whether near or far, a true friend will be there for you no matter how much time has passed by.

Some people may call them soulmates, or twin flames, or their siblings. The truth is everyone needs a friend like this in their life. When you find this, know the value; do not take it for granted.

REVERSE

Are you giving your time and energy to someone you think may be a chosen family member?

Maybe other friends or family have warned you this relationship is one-sided or toxic. Maybe you have fun and it is a way to pass the time. Or perhaps you have grown comfortable and are afraid to sever ties.

Deep down, you already know the answer to this. If you have doubts or are cautious about delving further or showing your true colors, then you know. This is not a chosen family member; this may not even be a true friend or acquaintance. Time to sit down and evaluate your surroundings and who you are giving your time to and putting your trust in.

Trust your instincts – what is your gut telling you?

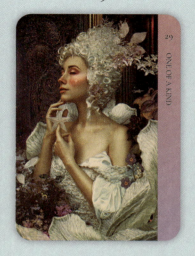

ONE OF A KIND

BELIEVE IN YOU

Are you numbing yourself with an addiction or self-medicating to get through the days? There are so many reasons why humans do this. Perhaps you are a survivor of trauma and it helps keep your thoughts or nightmares at bay. Maybe you are unhappy in life, and feel stuck. Whatever the reason is, you are being asked to know your worth. Maybe start a journal and pour these doubts, stories, and nightmares onto paper.

You are like a star – there is no one out there who is you. You are perfectly imperfect.

Start your day with at least one affirmation. Believe in yourself.

What unique gift do you bring into this world? Whatever it is that makes you happy and healthy, do it. Embrace it. Find ways to appreciate and celebrate your uniqueness.

If you are feeling stuck and in a self-destructive loop, talk to someone – anyone. Ask them not to judge, but rather to listen. This could be a huge help in getting you on the right path to self-worth.

REVERSE

Have you ever had a conversation with someone and found they take everything you say and turn it around to make it about themselves? Good, bad, or indifferent?

Sometimes others can over-share. This may be because they need to vent or share in order to get back to life as normal.

Hear them out; they may have no one else to do this with. They may also need to be reminded that they are unique. Once you have listened, perhaps you can gently remind them of this fact.

Your ear, kindness and words might be the turning point in someone's day, week, or life.

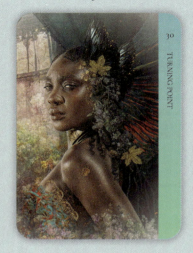

TURNING POINT

CHOICES WE MAKE

There are pivotal moments in life that are huge turning points. It's the choices we make that lead us down certain roads that are sometimes forked, meaning you need to make further decisions along the way. These moments can be exciting and even nerve-racking, or maybe you are absolutely ready for this and can enter these turning points fearless and brave, with your arms out-stretched.

The unknown is indeed scary – but you've got this. Have trust in your choices, and face these moments head on. It is nice to reminisce and think about things the way they once were, but change is calling, beckoning you to shake things up a bit, helping to shape this thing we call life.

Look deep inside yourself … you already know the steps to take that will help you navigate these landmark moments.

REVERSE

This is an analogy I told my children when they were young: you can walk a path and make new ones, but if you walk in the same circle constantly you will eventually find you have dug yourself a ditch or moat, and it may be hard or near impossible to get out of.

What exactly does this mean? Simply put – we need a fork in the road and change to grow as a being.

Maybe you are facing a significant event in life that frightens you and leads you back to walking in the same old circle – the one you are all too familiar with.

Now is the time to be daring – face your fears and move forward.

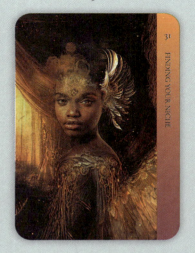

FINDING YOUR NICHE

DO WHAT YOU LOVE

Do what you love … Finding your niche is fun and exciting. It gives you a chance to try all the amazing things you want to until you find your calling.

Everyone has a gift, a talent, and something they are amazing at. You are being encouraged to take steps to find out what yours is.

Take a class, buy some art supplies, grab whatever you think you will need in your niche toolbox and go for it.

If you already know your niche, then hone it, study it, and be amazing at it. If you are lucky, it may become your livelihood.

There is nothing more rewarding in your "work" life than getting to do what you love and are good at.

REVERSE

Are you a jack of all trades, master of none? That is absolutely fabulous because the entire saying is "A jack of all trades is a master of none, but often times better than a master of one." Maybe there are many things you love doing and are good at, which means you can then offer this world many brilliant things. You have honored yourself in such a wonderful way.

Perhaps you are the total opposite of this and feel clumsy and awkward trying new things. Maybe yours is more of an academic talent. When you find your niche it will feel almost natural, like something you didn't realize you were even missing out on. Take your time, don't force it, and have patience.

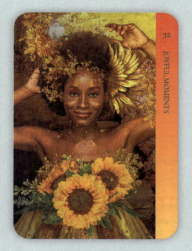

JOYFUL MOMENTS

SHINE BRIGHT

Joyful moments are a personal magic – soak them up like sunbeams. Laughter makes you glow; it makes you shine from within. It is a wonderful way to lift your heart, mind, and soul.

Joy fills you with a special exuberance unlike any other, releasing happiness chemicals naturally into your body. These chemicals are an essential part of being healthy and living a stress-free life.

But apart from the science of it all, these moments create beautiful memories you can share with those who impact your life in a deep and meaningful way, building an even deeper bond with the beings you share your life with.

This card offers an invitation to do something joyful with those who have a deep meaning in your existence.

REVERSE

Are you a "Debbie Downer" who looks for the negative in everything you do? Do you expect the worst and hope for the best? You need a little dose of those happiness chemicals we were just speaking of.

Let go of all that negative thinking and let the moment be spontaneous and joyful.

Take a walk in nature or a trip to your favorite bookstore. Get out and do something that could let joy into your life.

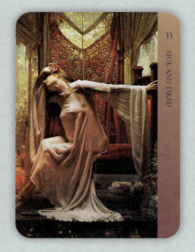

SICK AND TIRED

GUILT FREE

Have you recently – or perhaps always – taken on too much in your life? Maybe as a spouse, parent, worker, cook, chauffeur, caregiver, or other such role where you are expending your energy?

In this current age we live in, it is deemed normal to do so many things. But is doing so much healthy for your mind, body, and soul? It is okay to say "No" to something that will make you sick and or tired. Learning to say "No" without guilt could be the most

important thing you learn as an adult. People are afraid to say "No" because of the potential consequences. Ask yourself if you are afraid of the answers to the following questions:

Will saying "No" hurt my work situation? Will saying "No" make someone think I am selfish? Will saying "No" make me miss out on something? Will saying "No" make me seem mean or like I do not care?

Here is the real question to ask yourself – will saying "No" give me time to breathe and be healthier and happier?

A healthier and happier you will benefit all those you interact with in your daily life. It might take baby steps to get to where you need to be, being able to say "No" without feeling guilty, so start with something small and work your way up.

REVERSE

You are not worried about being sick and tired, because you know exactly how to say "No" without guilt – the elusive zero calorie "No". You are to be applauded for this. You are quite a rare find. Keep up the great work!

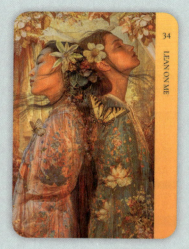

LEAN ON ME

SUPPORT SYSTEM

Do you have a support system or community, or someone you can lean on? Everyone needs someone or "some ones".

Community is important. It can sometimes be a cure for loneliness, finding a group of like-minded people you make a true connection with, people you can count on.

Maybe there is no community group readily available near you. Perhaps you could find a book club, a sewing circle or a "church"

instead – somewhere you can find your people. You could also reach out to your friends and neighbors to start a new community group of some sort.

A genuine community will be like your own personal cheerleading squad, and you can offer the same in return and be someone to lean on yourself.

REVERSE

Are you in many groups, small communities, squads? Are you finding what you need? Or are you over-stimulating and surrounding yourself with people to fill a void?

This is something to consider, because if you are missing true connection within your community then you might be trying to find your niche or missing the bigger picture of just what exactly community is.

Perhaps it's time to let go of some groups you may think offer a sense of community, but where you are not finding genuine connection. Start with the ones you feel least connected to and work your way from there.

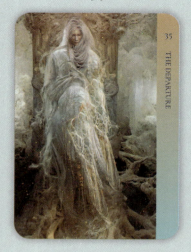

THE DEPARTURE

SAYING GOODBYE

The departure is exactly what it sounds like – beyond saying goodbye, it is likely the last time you will experience this moment. This is never an easy time – even if we think we are fully prepared.

Saying goodbye can be heartbreaking, life altering, and some of the hardest moments you will face.

When you choose this card, you are not being asked to move forward or to end the "mourning" process. You are being asked to

respect, remember, and honor what you are mourning – be it a loved one, a situation, a relationship. There are so many variables regarding what we mourn.

Remember, there are no rules on how to grieve, and never take meaningful relationships for granted.

REVERSE

Are you so afraid to say goodbye you never say hello? Making deep valuable connections in life is part of what makes you human. Whether through personal relationships or work, saying goodbye is never easy. But there will always be a time to say goodbye.

Knowing this should sweeten the time and moments you share with others. Make every second precious and fulfilling and start building valuable connections.

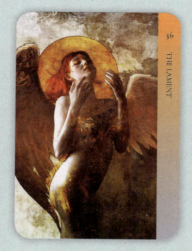

THE LAMENT

LETTING GO

You have wailed, cried, mourned, and sat in your grief for so long now it has become a lament, a sort of sorrowful song that may start to define who you are.

A lament is not always about death; it can sometimes be about regret.

You have a tendency to get caught up in a loop of memories, what ifs, and sorrowful woes – endlessly reliving things in your mind until it begins to wear on who you are becoming.

While lamenting can be a healthy process, it is up to you to say when the process is over. Try not to let your lament evolve into who you are, or define you as a person. There may be a way out if you find healthy outlets such as music, art, and writing . . . Little by little, make your way to the light at the end of the tunnel.

REVERSE

Have you recently said goodbye and faced it with grace and elegance? Or are you simply in denial? It's important to know the difference. A healthy lament is healing, while denial could cause damage further down the road for you.

Take a close look at this and know the difference.

Sometimes in goodbyes there is celebration – of life, a move, the end of a toxic relationship. Even in the worst-case scenarios for goodbye, you must mourn. Whether it is a life you once led, a place you lived and loved in, and, yes, even a toxic relationship – while the goodbye is right to be celebrated in this case, you must also mourn the life you led.

Take time to find the proper closure for you.

ABOUT THE AUTHOR

Jena is a self-taught artist who works in digital and mixed mediums. Her belief regarding art is that the only limit is your imagination. In her experience, art should always move and stimulate the viewer emotionally, be it good or bad.

Jena has been using photo manipulation and/or collaging to create her artwork for the last few years. Using these mediums, Jena has illustrated 20 oracle and tarot decks for some of the biggest publishing houses. She has collaborated with some of the most well-known names in the industry and is also creating art with words as an author herself.

Her body of work is both prolific and eclectic, and each piece tells its own story.

Jena welcomes you in taking a trip into her imagination through her works.

AUTUMNSGODDESS.COM
The only limit is your imagination.

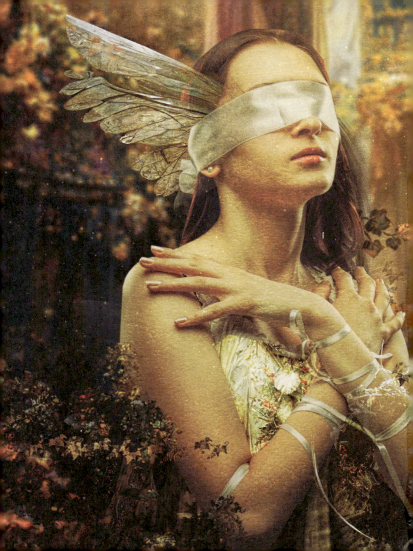